MVFOL

look out, world

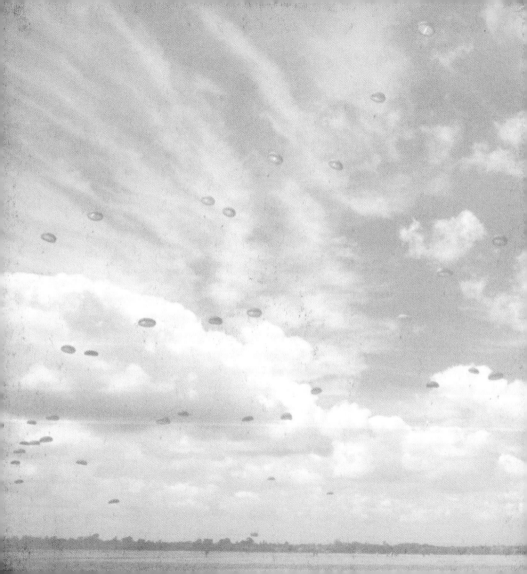

look out, world

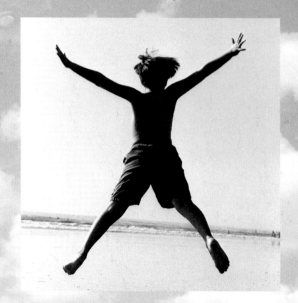

meaningful quotes for graduates

edited by tom burns

BARRON'S

First edition for North America produced 2006
by Barron's Educational Series, Inc.

© 2006 Axis Publishing Limited

All inquiries should be addressed to:
Barron's Educational Series, Inc.
250 Wireless Boulevard
Hauppauge, New York 11788
www.barronseduc.com

Library of Congress Control No: 2005922472

ISBN 13: 978-0-7641-5901-5
ISBN 10: 0-7641-5901-1

Conceived and created by
Axis Publishing Limited
8c Accommodation Road
London NW11 8ED
www.axispublishing.co.uk

Creative Director: Siân Keogh
Designer: Sean Keogh
Editorial Director: Anne Yelland
Production: Jo Ryan, Cécile Lerbière

Printed and bound in China

9 8 7 6 5 4 3 2

about this book

High school and college graduation is a time to celebrate success and look forward to a bright future in which anything is possible. *Look Out, World* is a collection of remarkable thoughts, mantras, and sayings that are full of joy, anticipation, congratulation, and goodwill to reflect this exciting time. Complemented by a series of beautiful photographs, these words of wisdom, written by real people and based on their real life experiences, are guaranteed to inspire and to become a lifelong reminder of this very special time.

about the author

Tom Burns has written for a range of magazines and edited more than a hundred books on subjects as diverse as games and sports, film, history, and health and fitness. From the many hundreds of contributions that were sent to him by real people giving their take on graduation, he has selected a collection that best sums up the joys, hopes, and aspirations of new graduates.

Please continue to send in your views, feelings, and advice about life—you never know, you too might see your words of wisdom in print one day!

Graduation is the beginning, not the end.

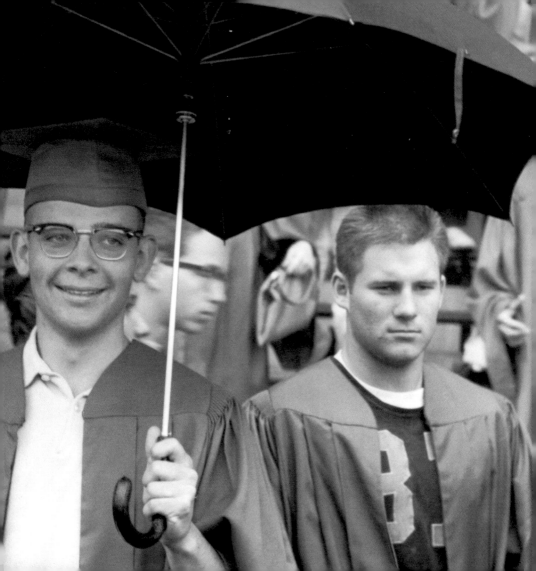

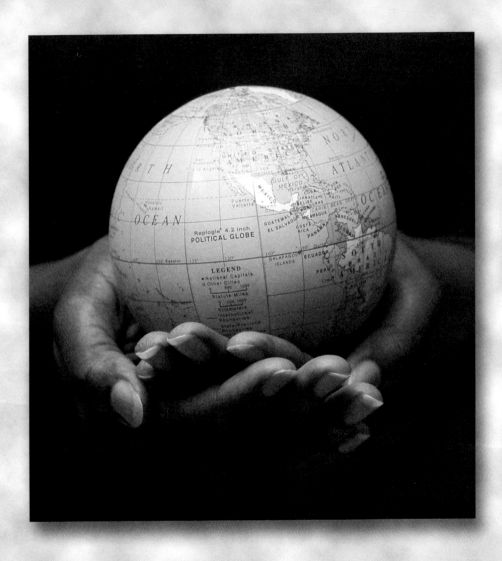

Graduation is your ticket
to change the world.

Seize the opportunities;
avoid the pitfalls; and get
home by six o'clock.

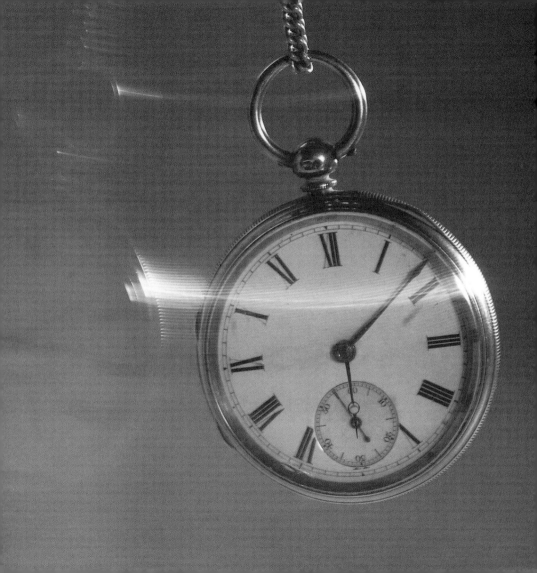

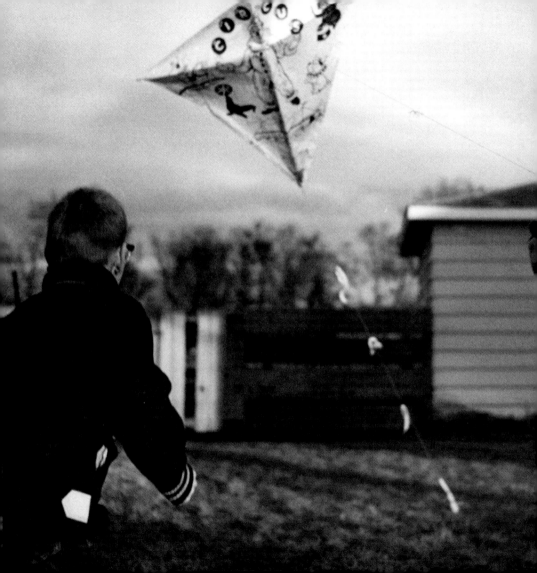

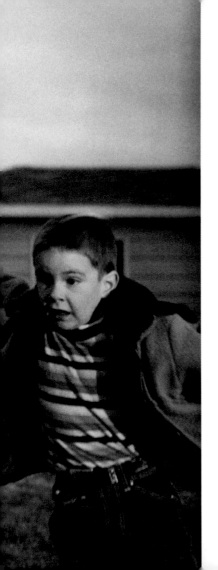

You cannot direct
the wind, but you
can adjust the sails.

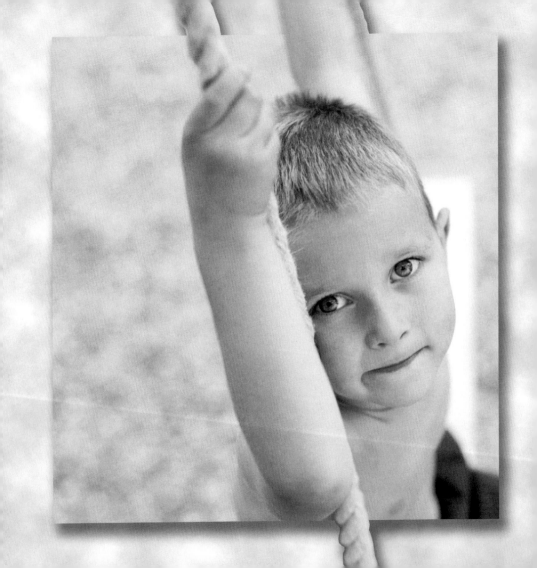

Don't become something…

…be someone.

So many people
can figure costs,
but so few can
measure values.

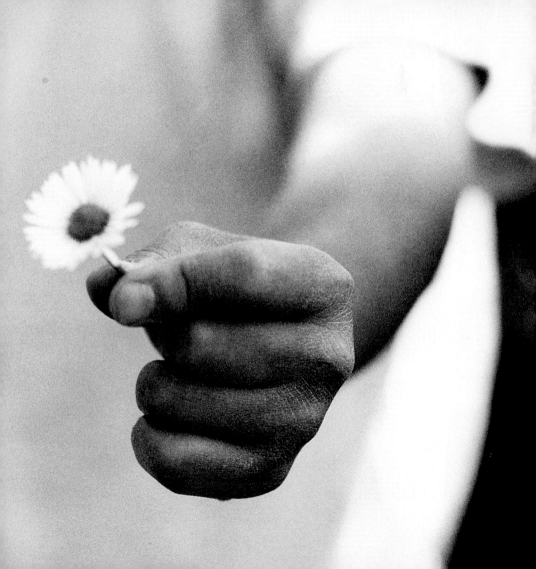

Your future is in
good hands…

…your own.

If at first you don't succeed, do it like your mother told you.

Find a job you love;
that way you won't have
to work a day in your life.

You can't cross
a gorge in two
small steps…

…take one
big leap.

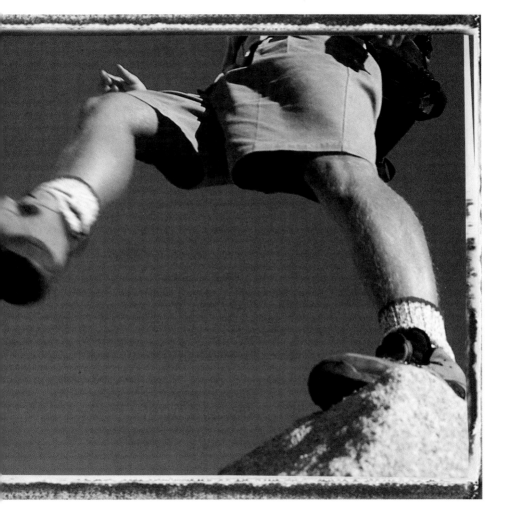

When all is said and done,
a lot more will have
been said than done.

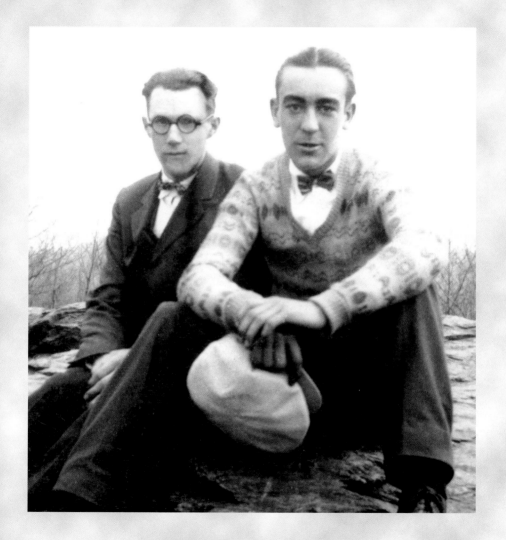

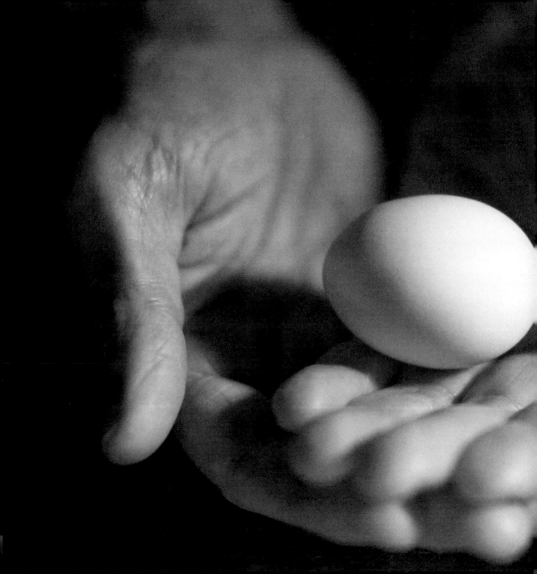

You are harder
than iron, stronger
than stone, yet
more fragile than
an egg.

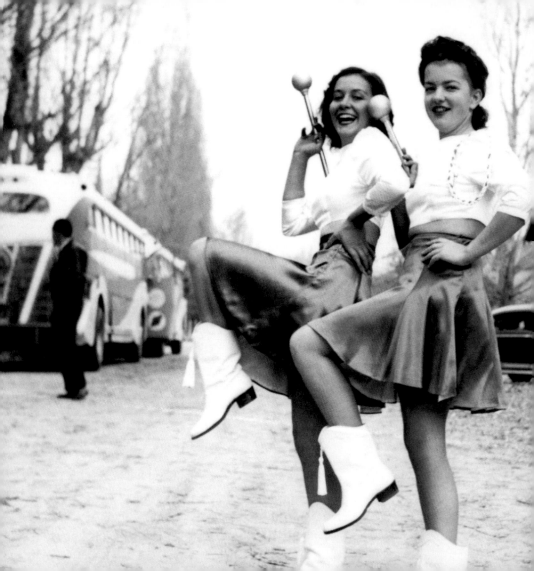

Act more…

…think less.

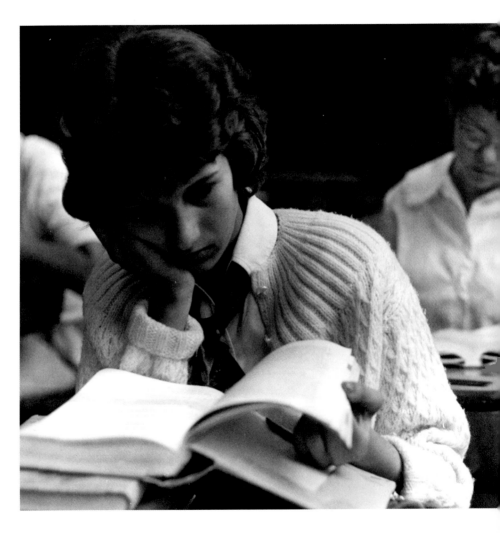

Don't stare at the steps:
start to climb them.

The best way out of a problem is through it.

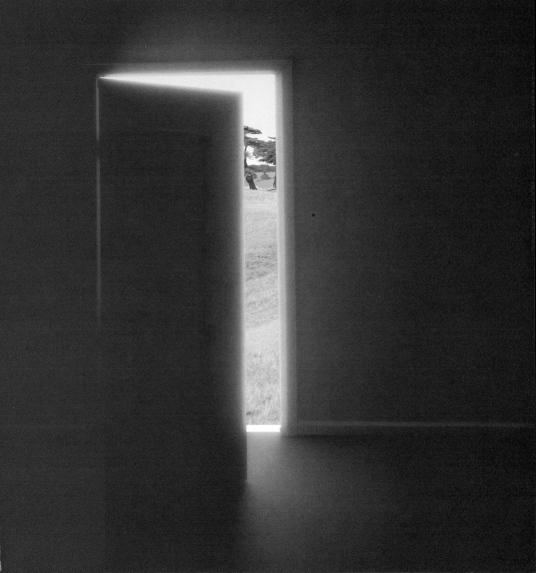

Aim for the moon—
that way, if you miss,
you'll end up with
the stars.

Know where
you are going…

…otherwise you
will wind up
somewhere else.

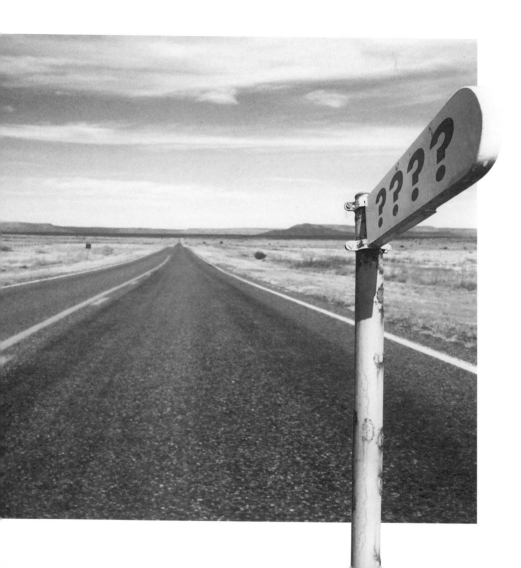

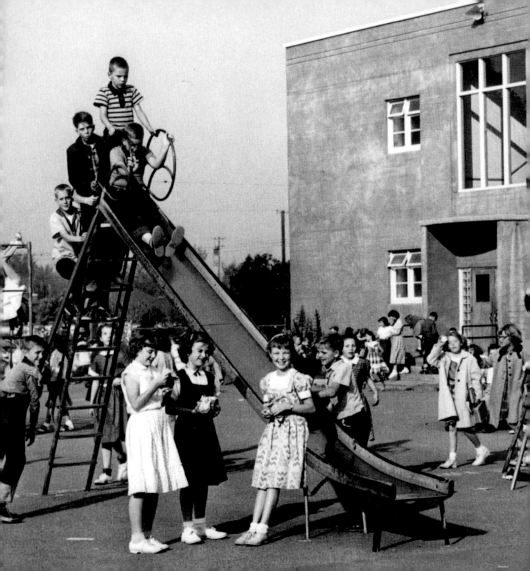

The rung of a ladder was never meant to rest on, but to hold your foot long enough to enable you to put the other higher.

Make your dreams
a size too big—and
grow into them.

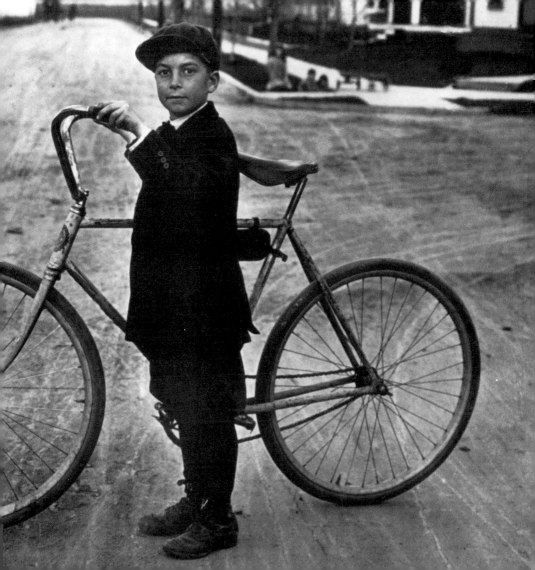

Life's problems wouldn't
be called "hurdles" if there
wasn't a way to get over them.

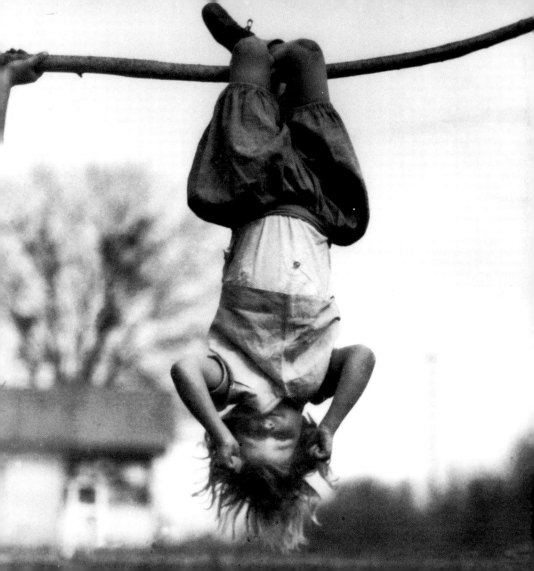

The best angle from which to approach any problem is the try-angle.

The distance is nothing,
it's the first step
that's difficult.

If you don't have time to do it right, you must have time to do it over.

If you aim at nothing,
you'll hit it every time.

When the world says
"Give up," try it one more
time. The only failure
is to stop trying.

Don't think of failure;
think instead of the
opportunity to start
again more intelligently.

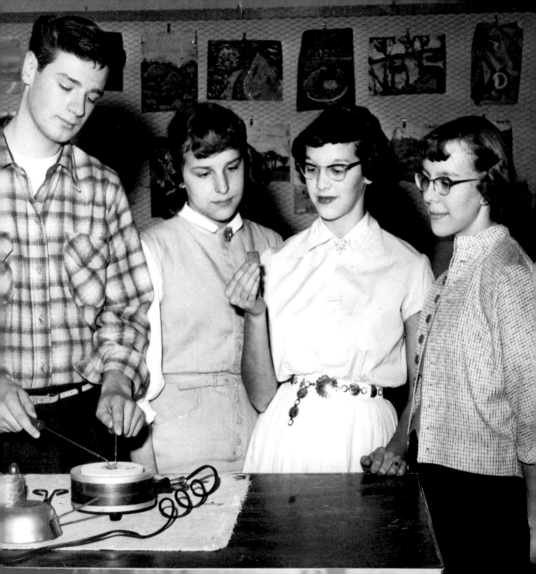

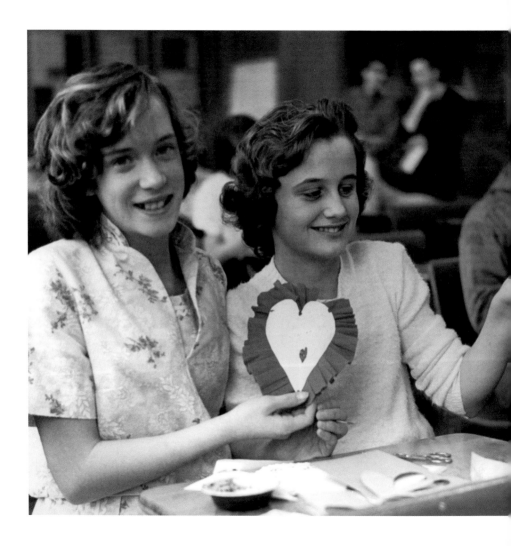

Opportunities are never lost; someone will take the one you miss.

Success is getting what
you want; happiness is
wanting what you get.

Keep in mind
that no success
or failure is
necessarily final.

If at first you do succeed—
try to hide your astonishment.

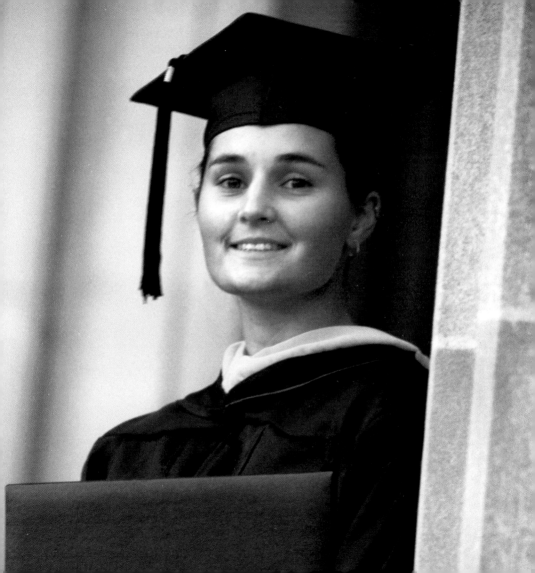

Think big thoughts but enjoy small pleasures.

Make your
optimism
come true.

Enjoy the little things because one day you'll look back and realize they were the big things.

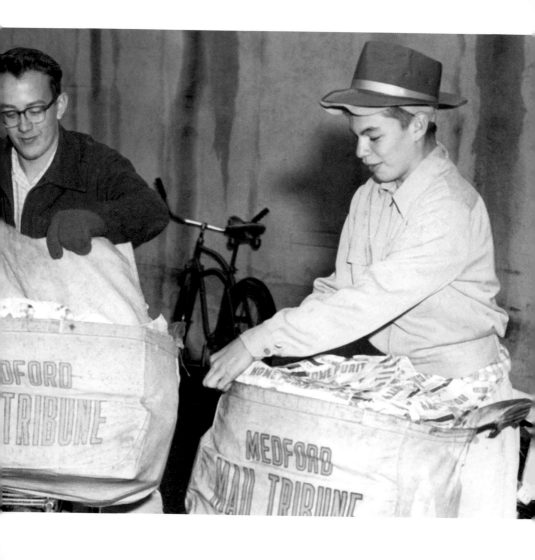

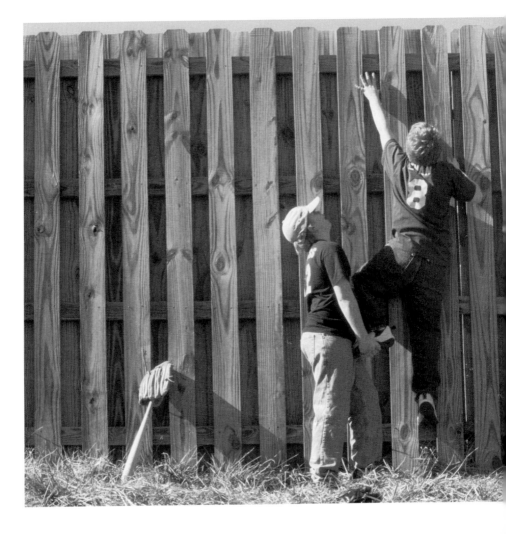

Go out looking for
one thing and that's
all you'll ever find.

The impossible
can always be
broken down
into possibilities.

I hope your dreams
take you to the corners
of your smiles.

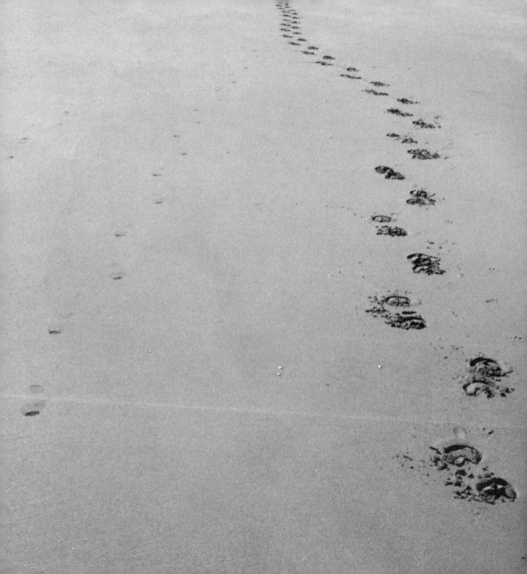

Don't wait for success, but rather go ahead without it.

Being a man of value is more important than being a man of success.

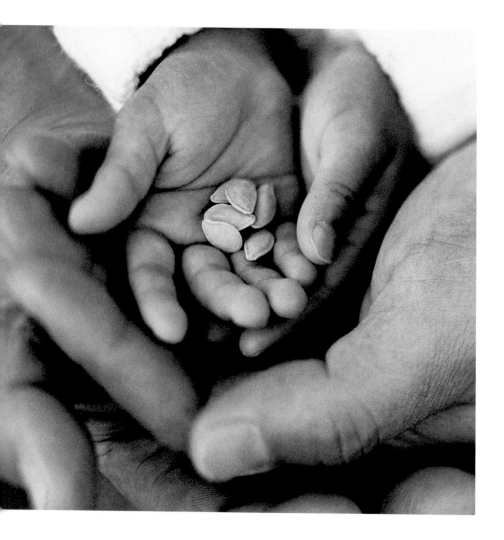

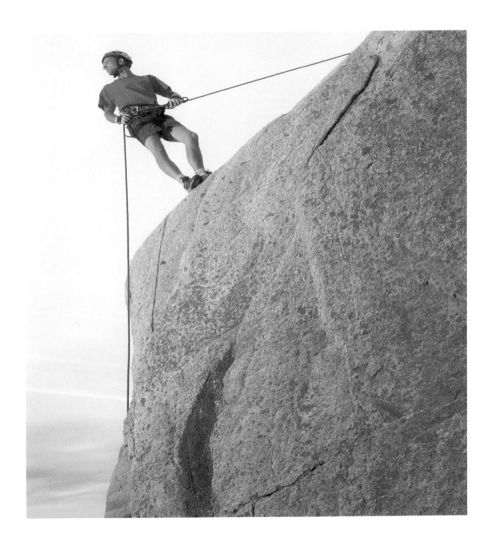

Be nice to people on your way up—you never know if you might meet them on your way down.

Anyone who dares
to try can have a
glorious life.

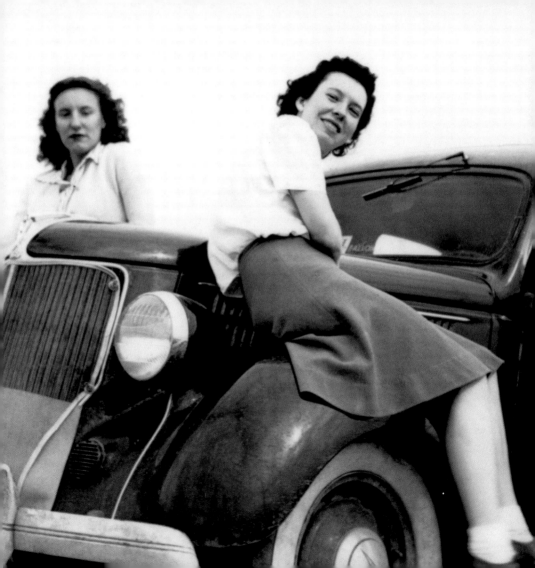

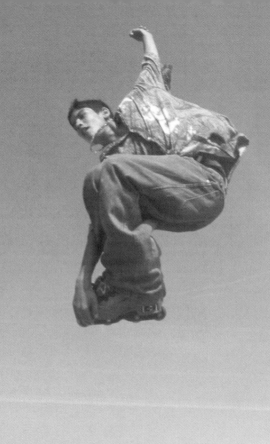

Great results require
big ambitions.

Work with the top people,
because they have
courage, confidence,
and are risk-takers.

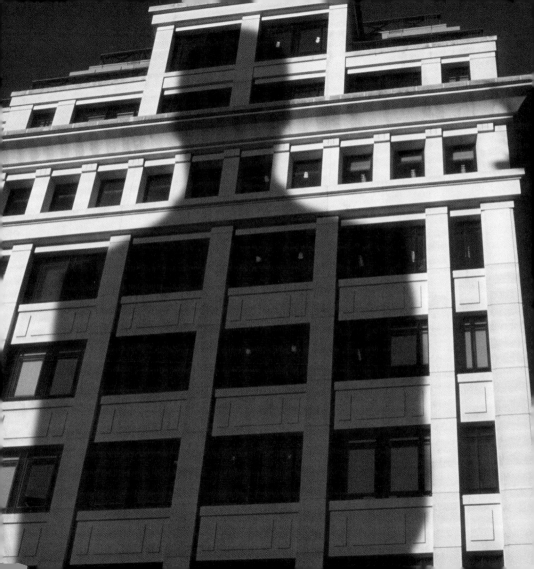

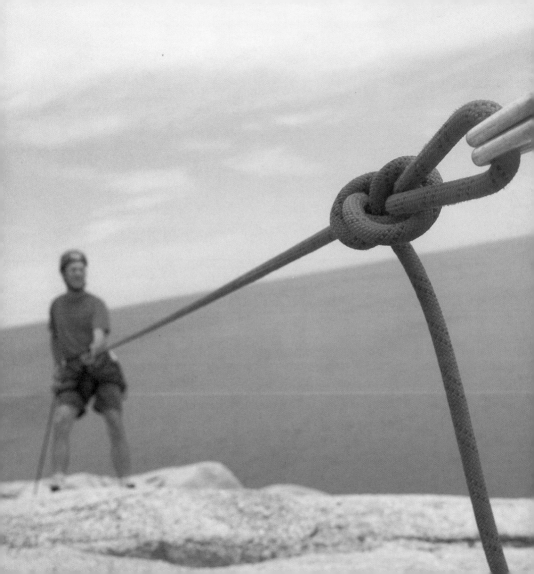

When you reach the end
of your rope, tie a knot
in it and hang on.

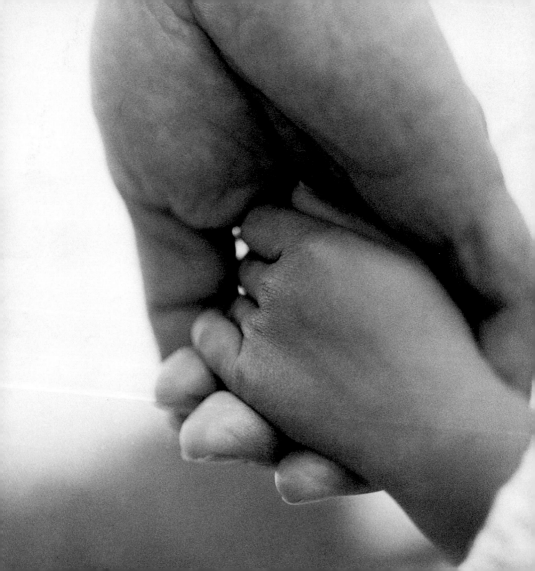

Hold on to
your dreams.

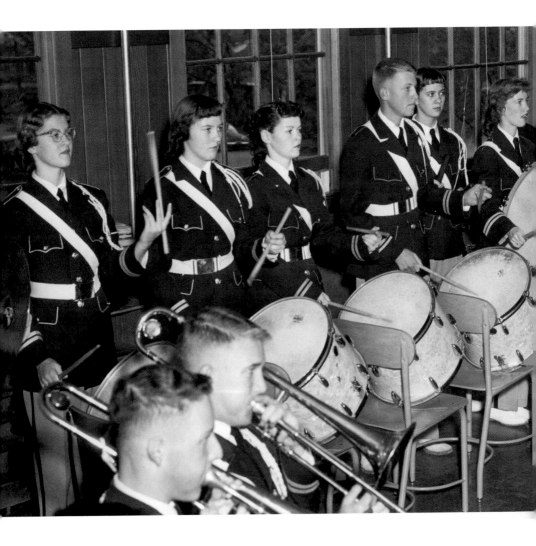

Ambition is never quiet…

…true leaders beat drums.

Since the world is
round, what feels like
the end may in fact
be the beginning.

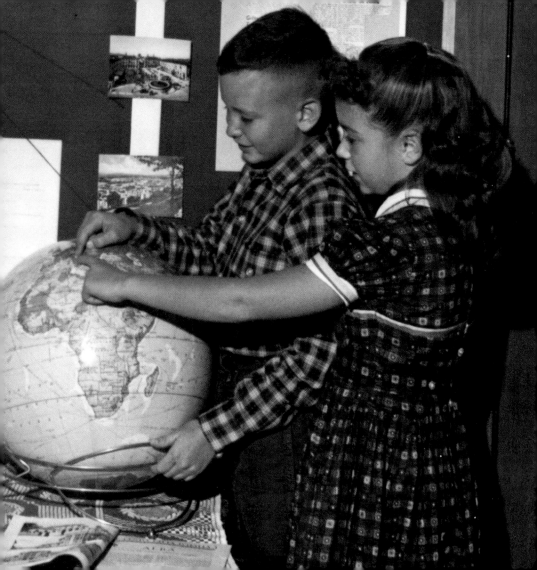

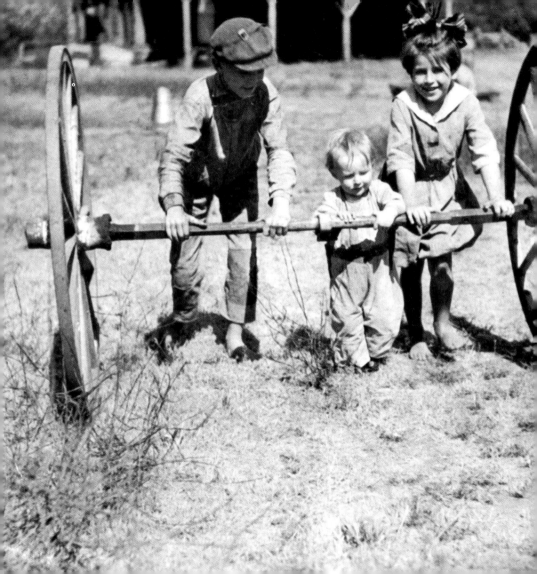

Every great journey
begins with a
single step.

Every one of us has in him a continent of undiscovered character.

When your heart
talks to you, take
good notes.

It is better to do something small than plan something grand.

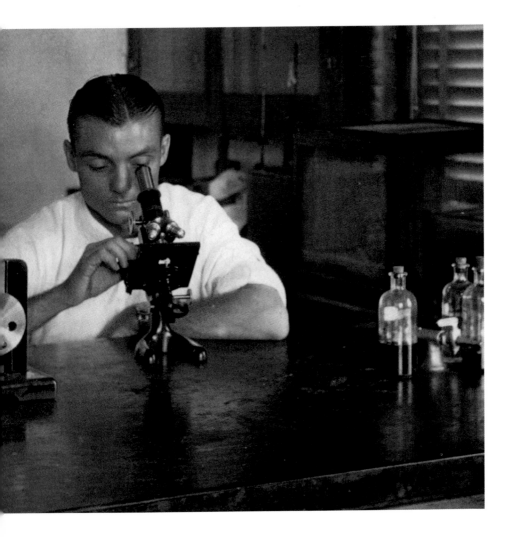

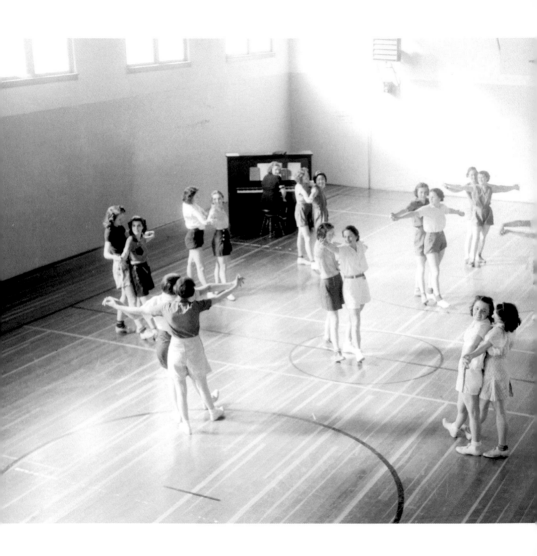

The first step leads
to the second.

The difference between "try" and "triumph" is a little "umph."

The distance doesn't matter…

…it's the experience that counts.

Don't be afraid of
going slowly…

…be afraid
of sitting still.

You are unique—just like everyone else.

The secrets of success
only work if you do.

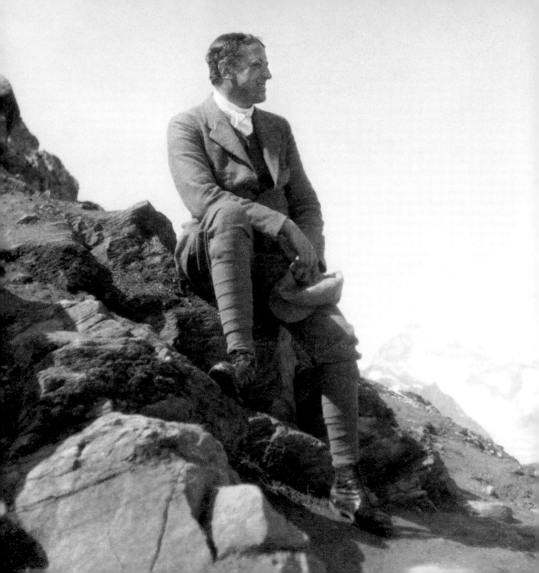

Success is a ladder you cannot
climb with your hands
in your pockets.

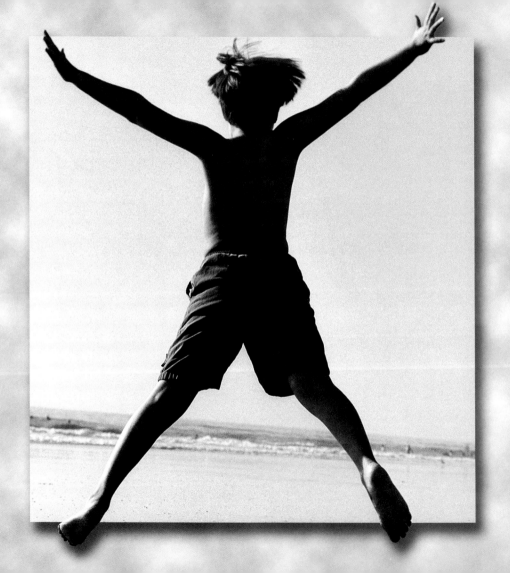

Some people dream
of success…

…while others wake up
and work hard at it.

Many an opportunity
is lost because a man
is out looking for
four-leaf clovers.

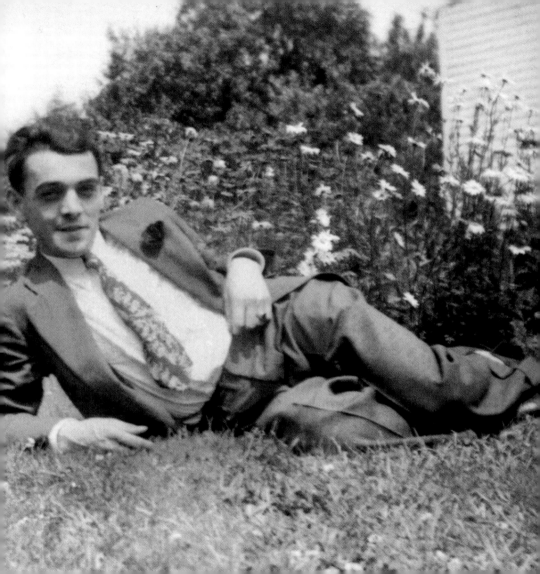

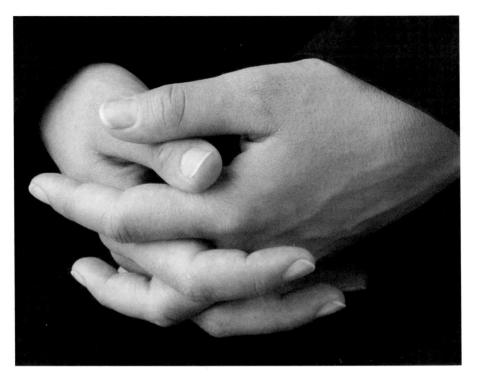

If you're waiting for something
to turn up, start with
your shirt sleeves.